Fractals
Of
Enlightenment

Part II: Creative Flow

By Alan Garfoot Jr. Cert. HE

ISBN: 978-1-326-18063-8

Alan Peter Garfoot (2014)

Lulu Press: London

Contents:

Staff of Atlantis	1
Psy-On	2
Spent of All Hope	3
High Infinite	4
Elite Magician	5
Alien Philosopher	6
Light-Bringer	7
Heat Ray	8
Solaris Grade	9
Callous Precision	10
Android Sophistication	11
Guardian Of The Source	12
Close Examination	13
Hive Telepathy	14
Telluric Waves	15
Vote of Confidence	16
Diplomatic Duty	17
Rei-Ki Psy-Power	18
The One of Arisia	19
Master Technology	20
High Warlock	21
Pyromancers Reflection	22
Judge Plebe	23
Horus Mage	24
Dynamics of Theron	25
Dual Self	26
Turned Into The Enemy	27
Three Times	28
The White Enchantress	29
Master 10	30
Observer Core	31
Soul Searcher	32
A Calm Focus	33
Interception Contact	34
Tellurian Prophecy	35
Shadow Shield	36

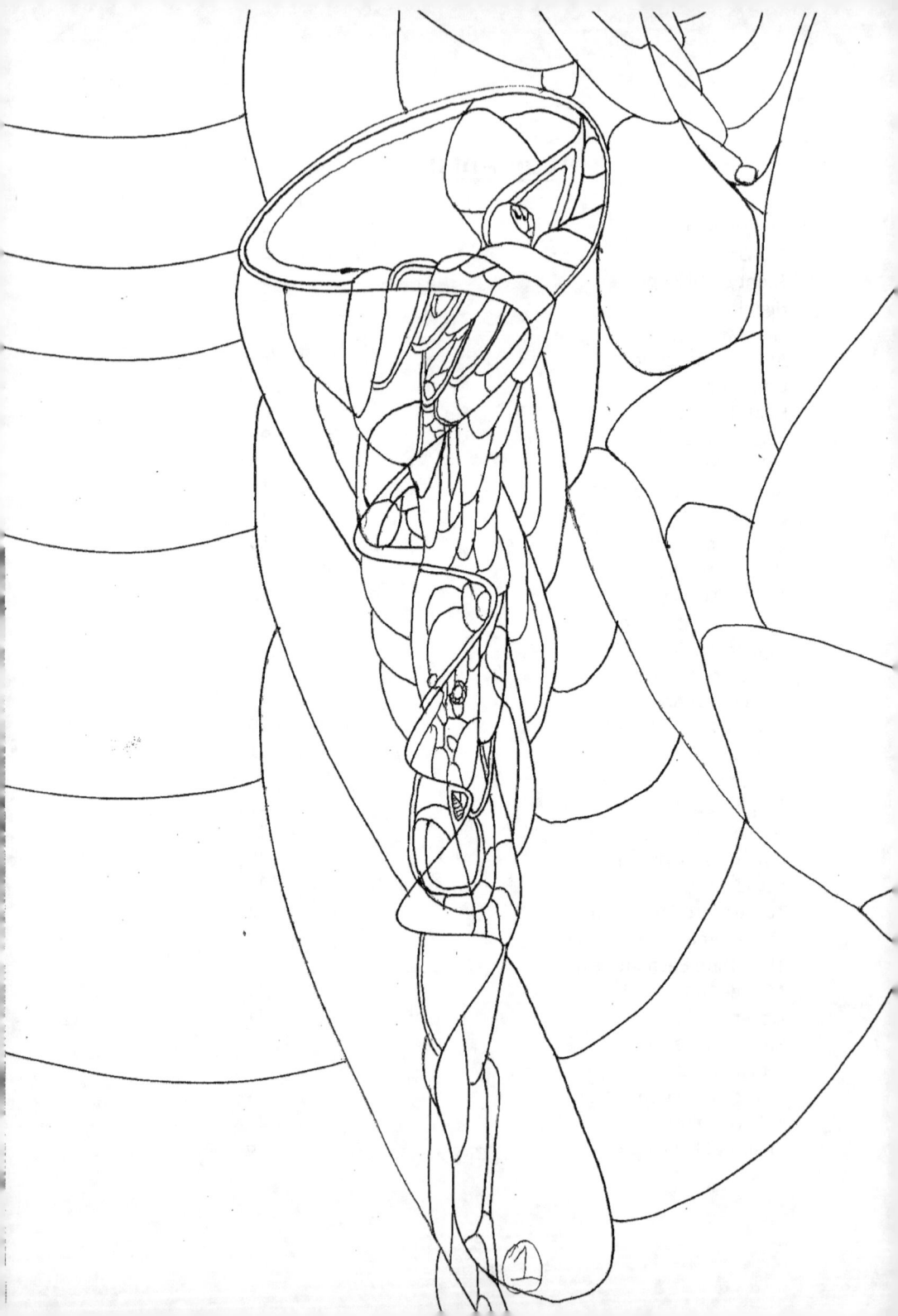

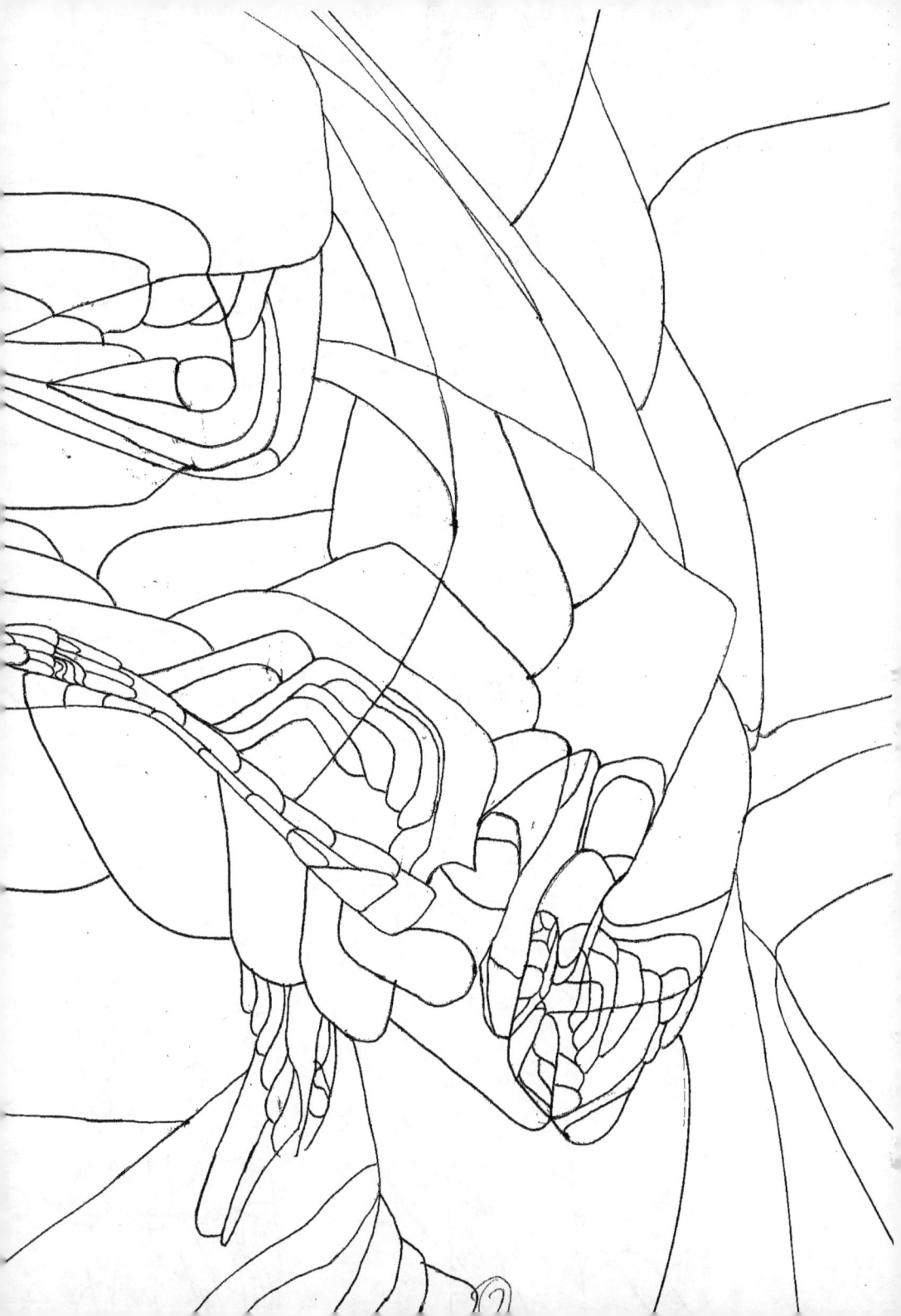

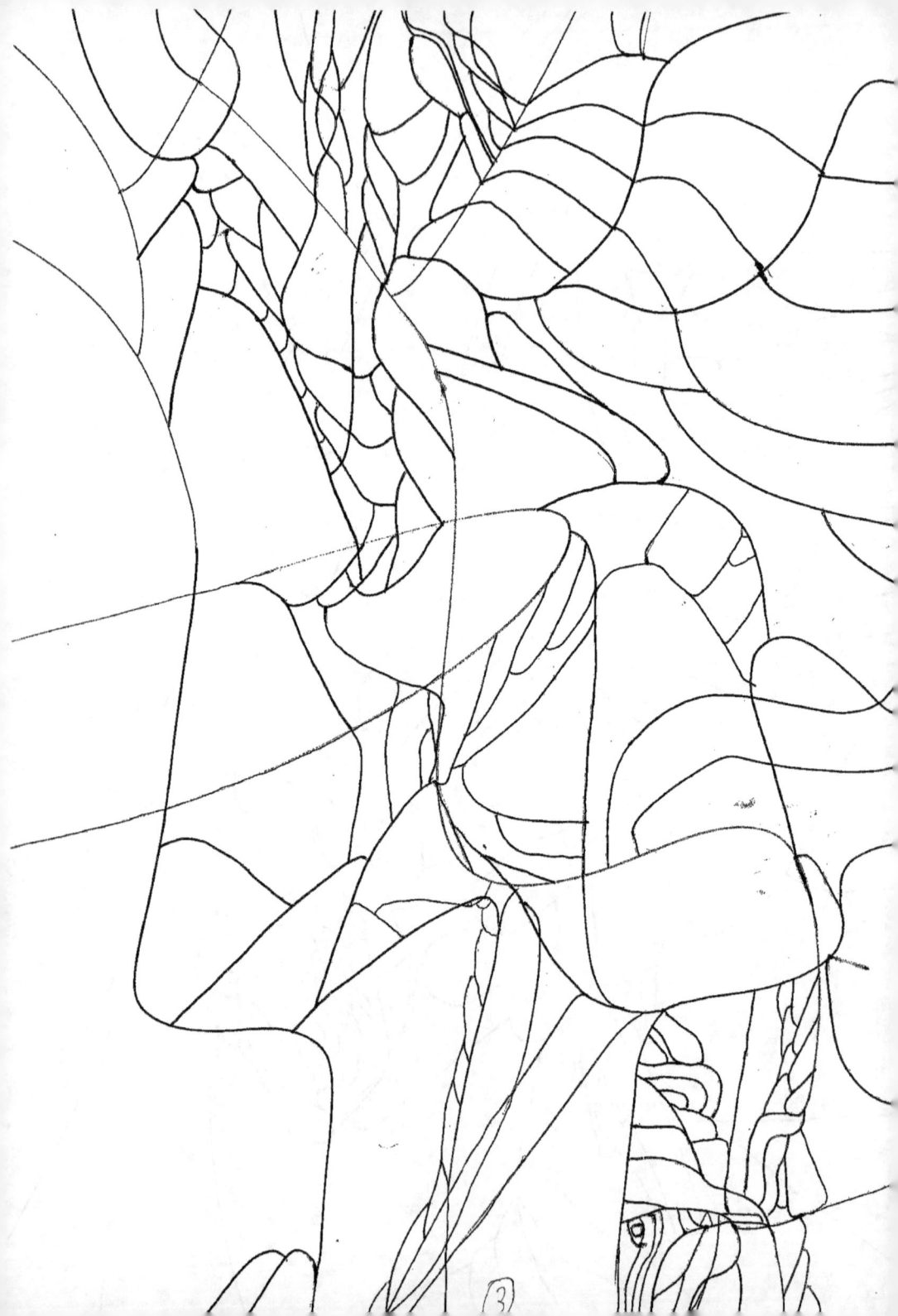

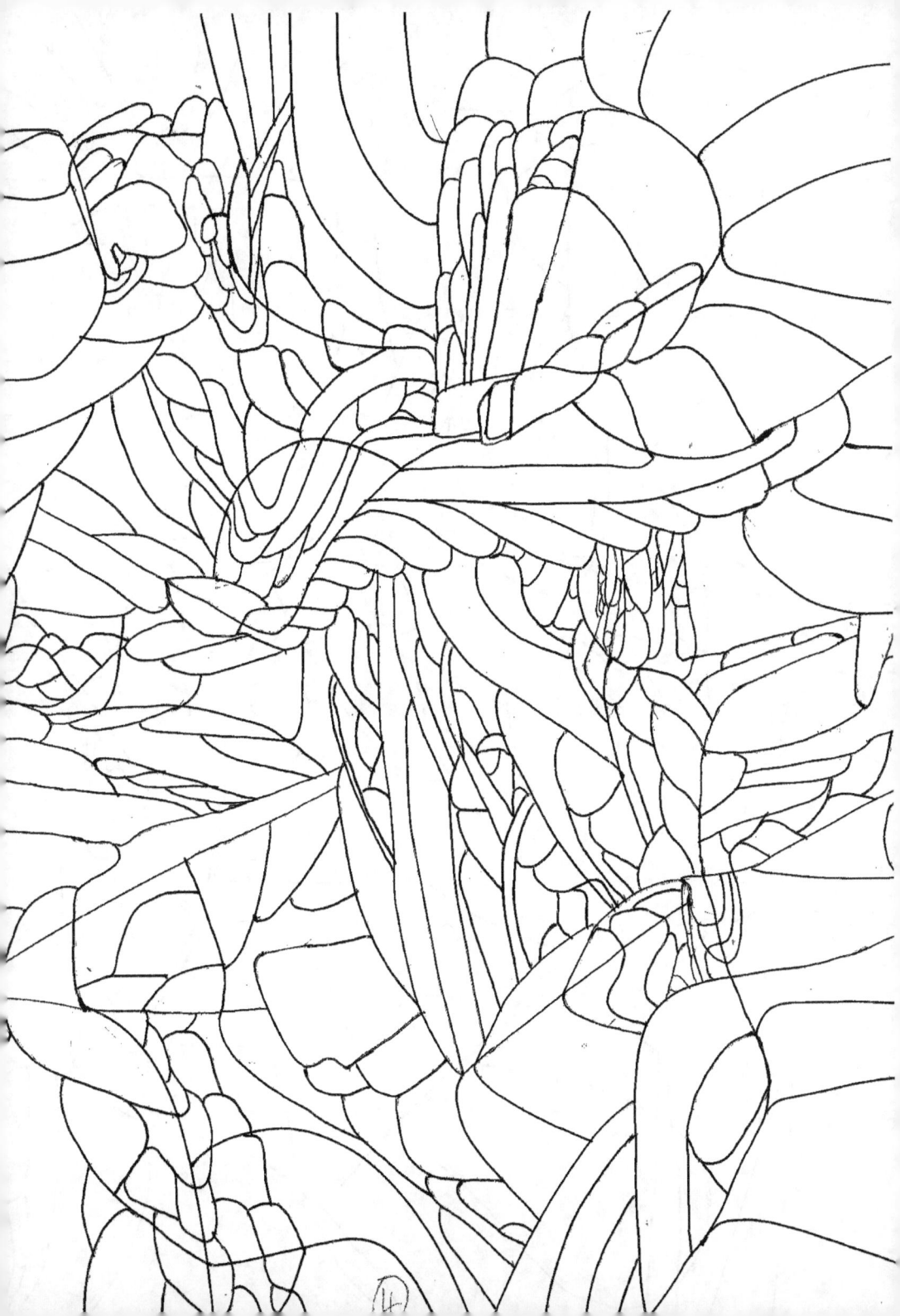

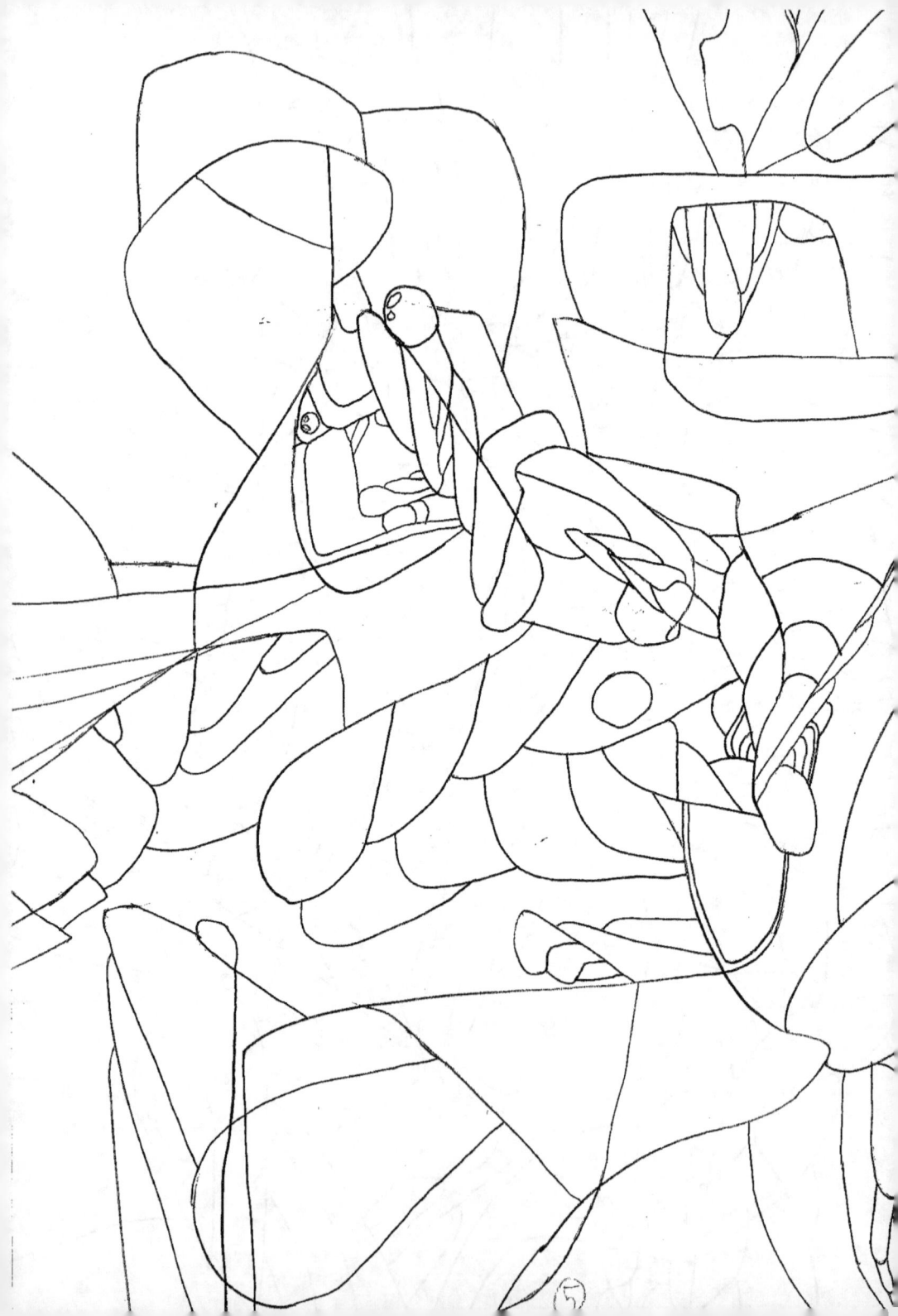

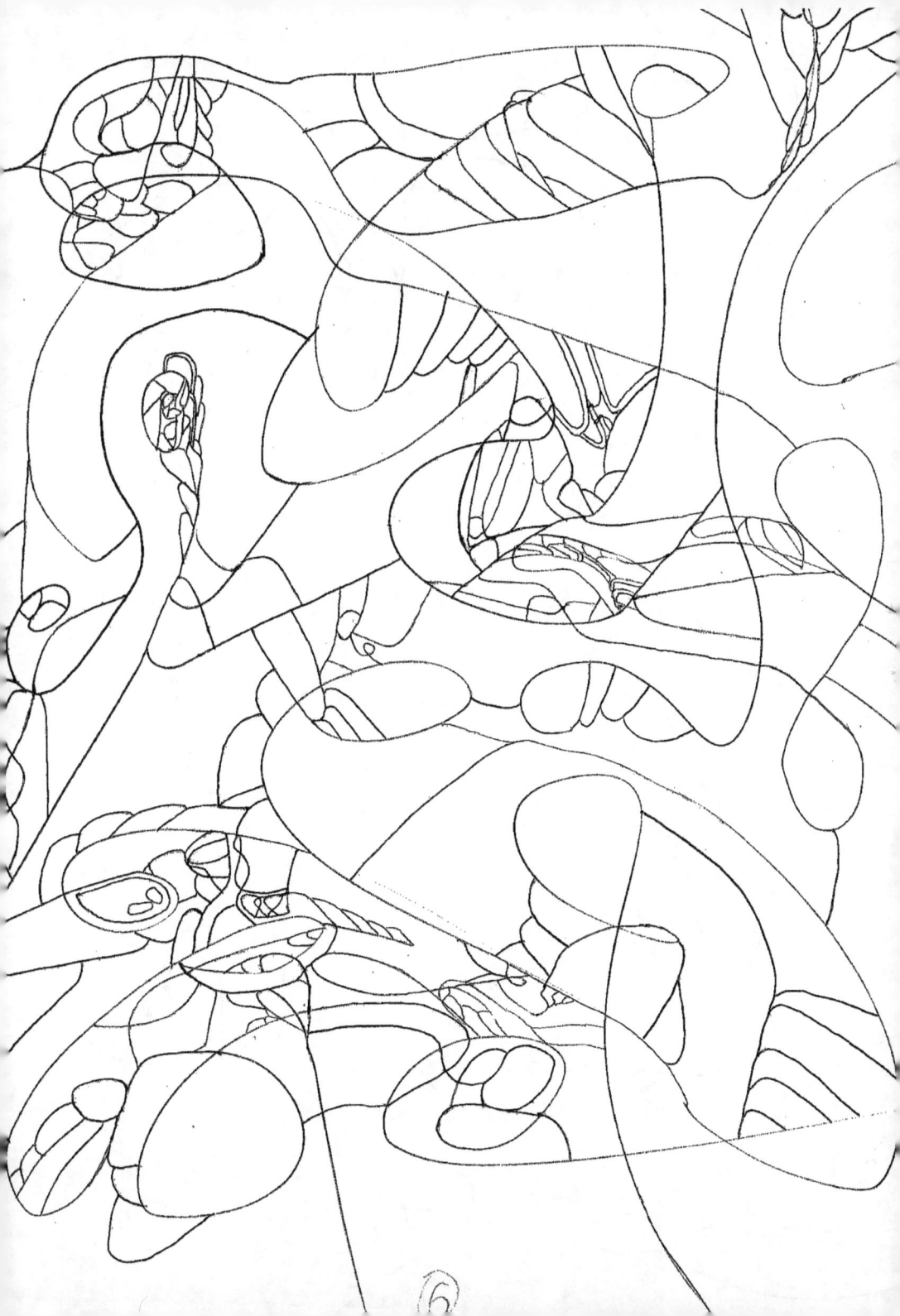

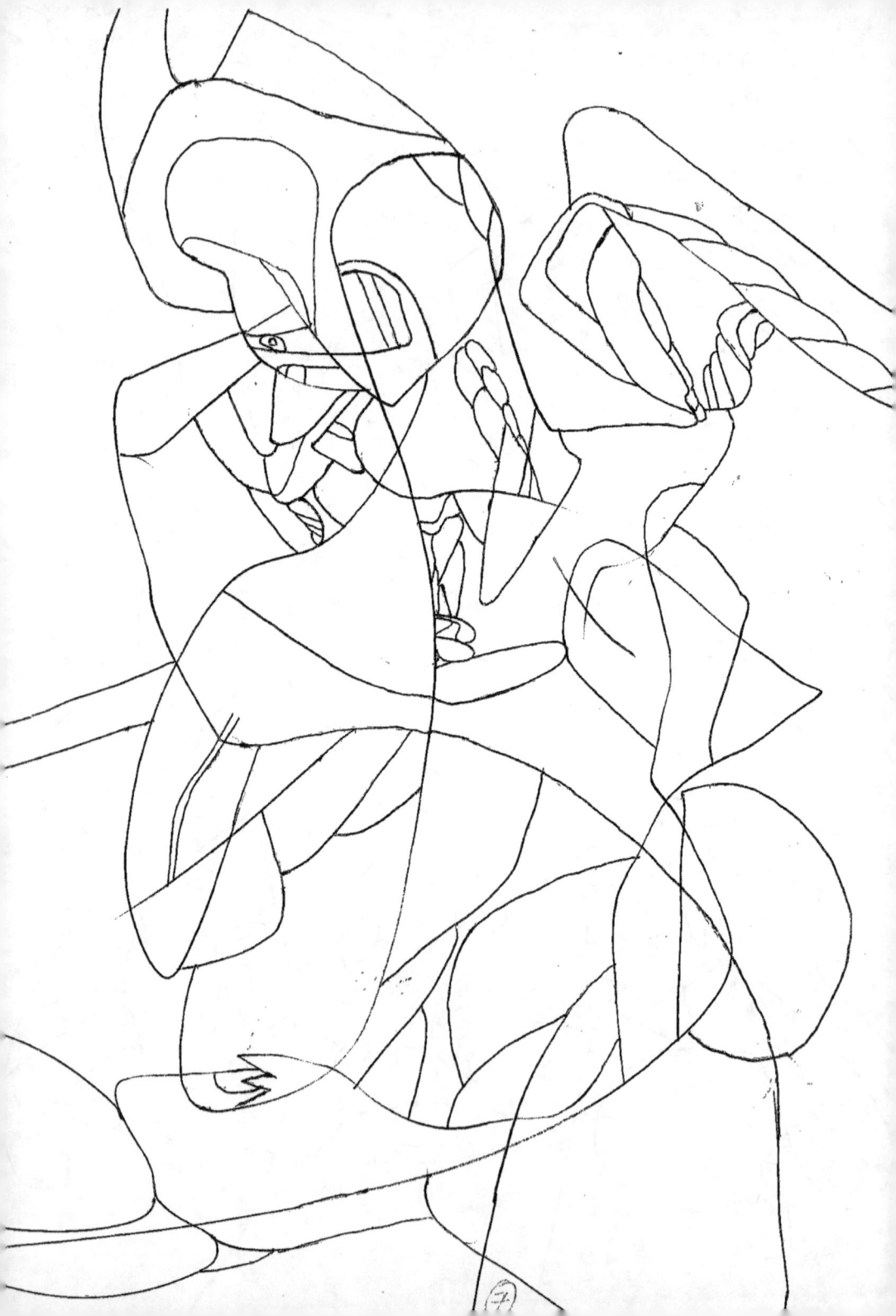

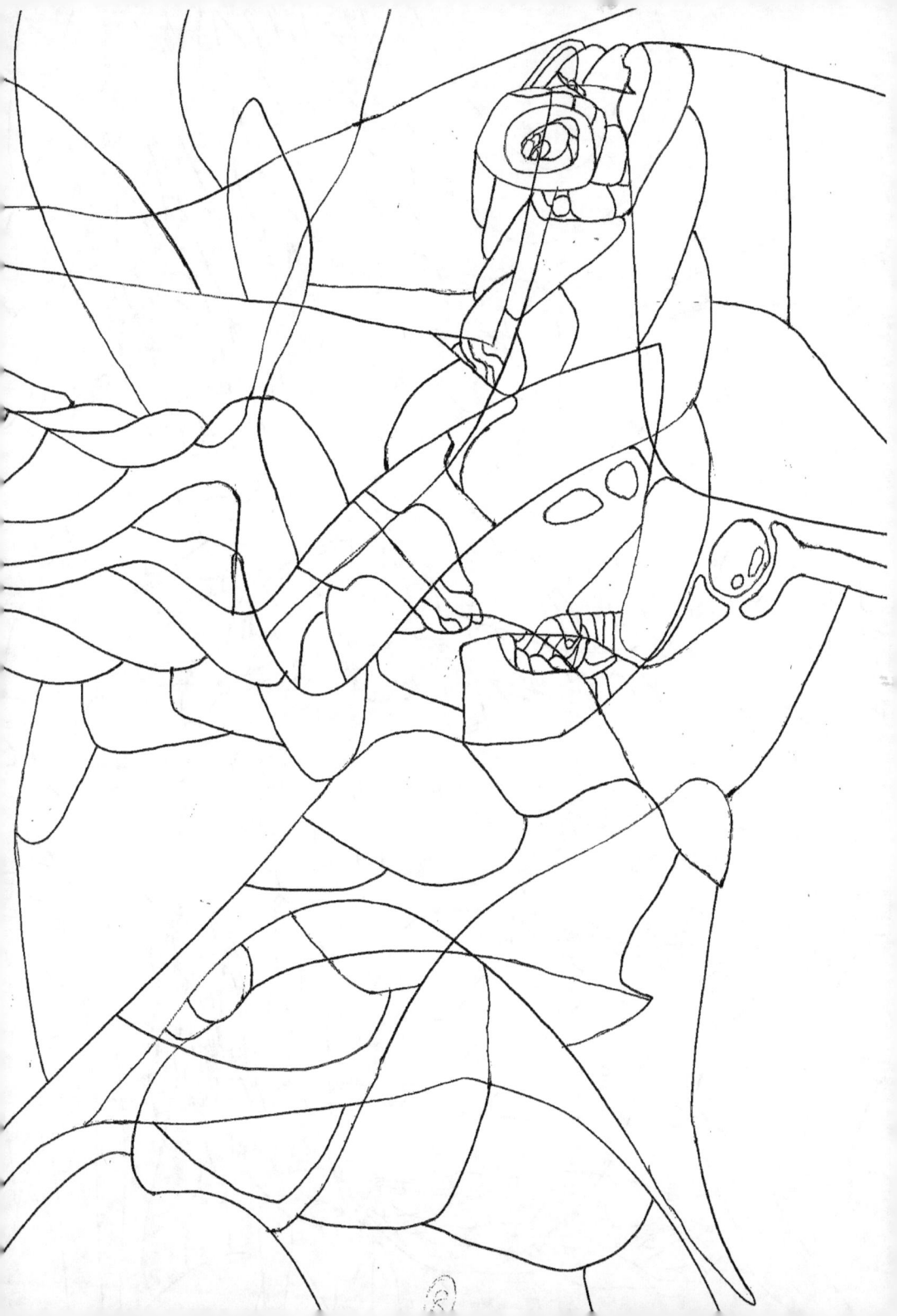

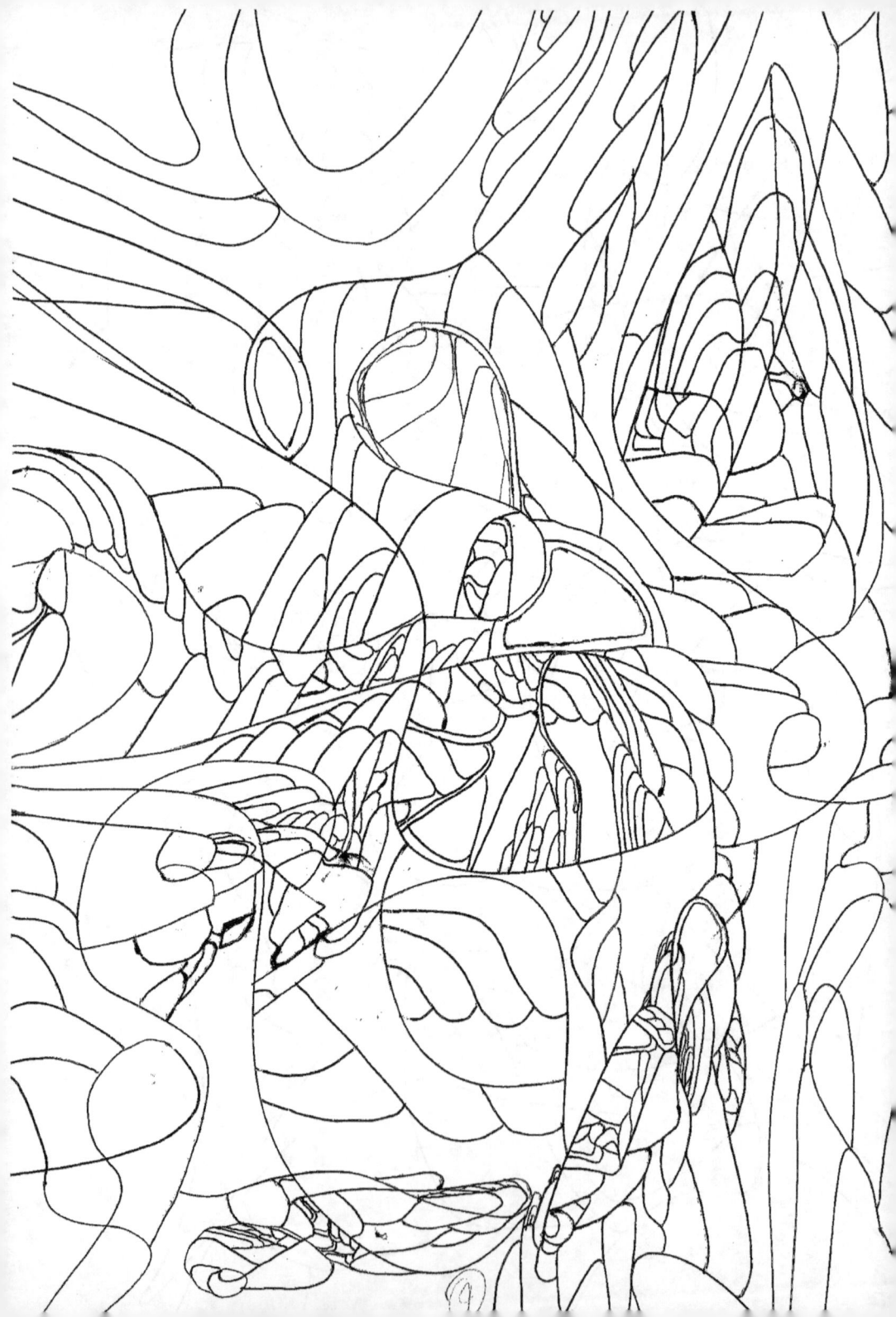

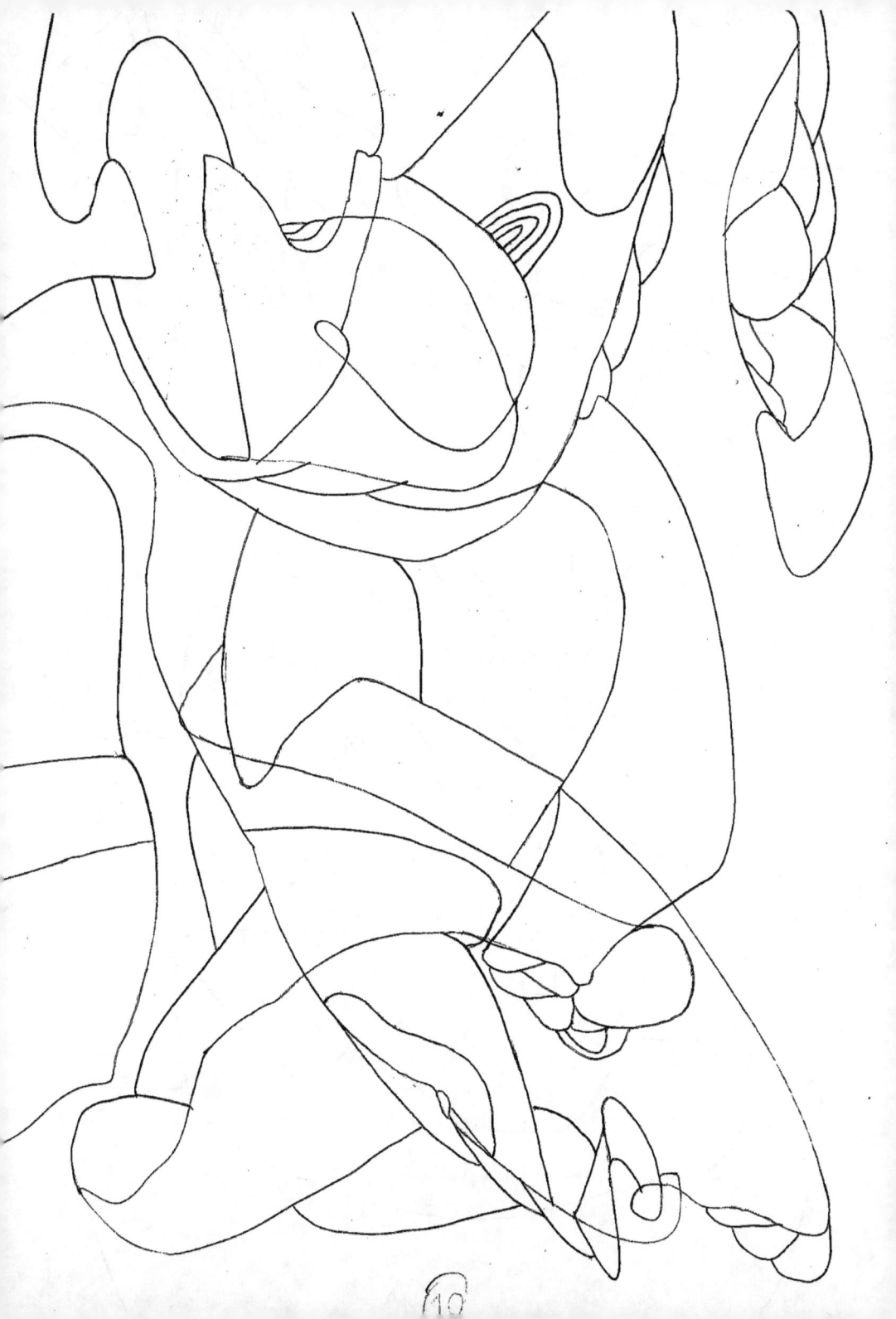

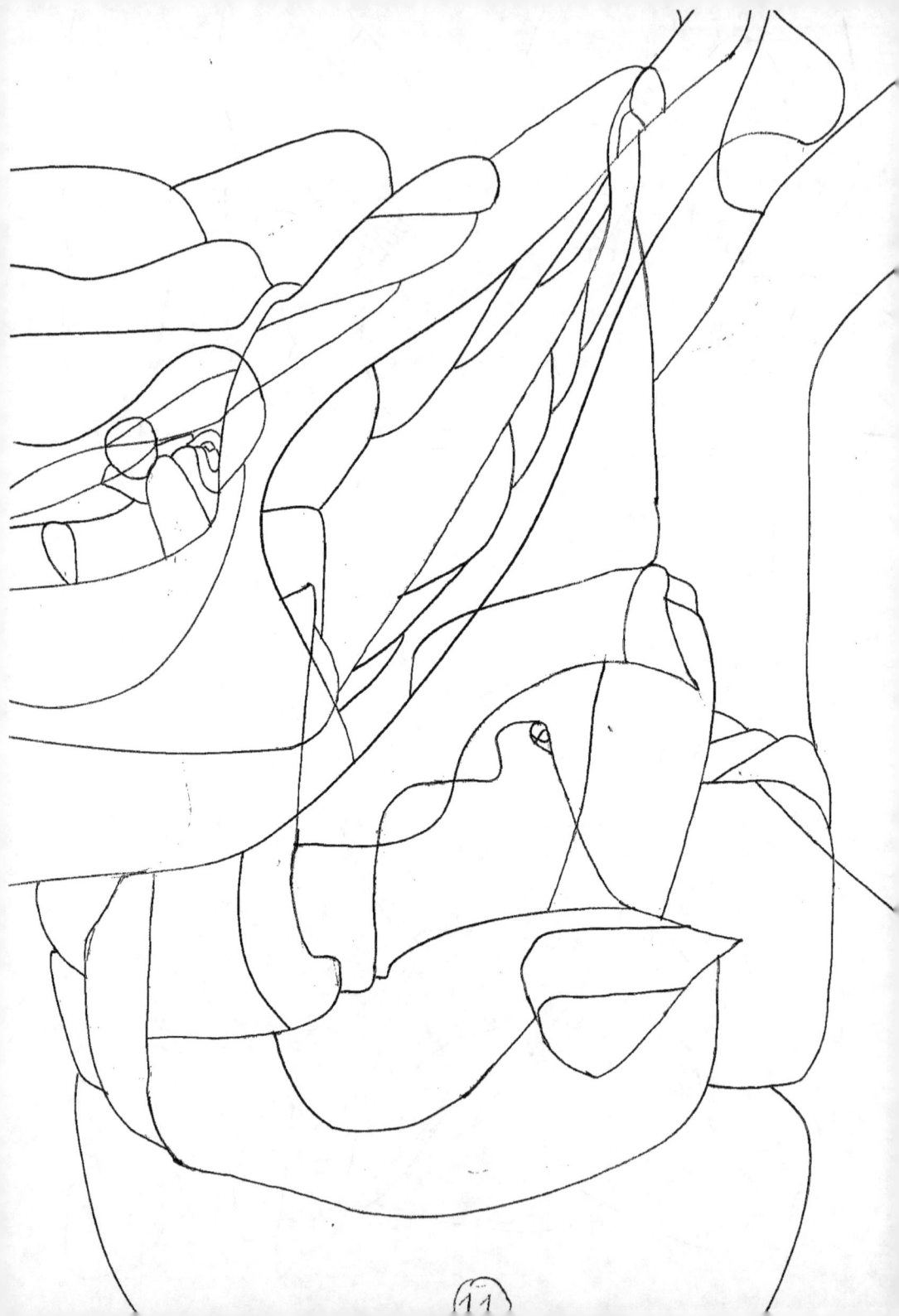

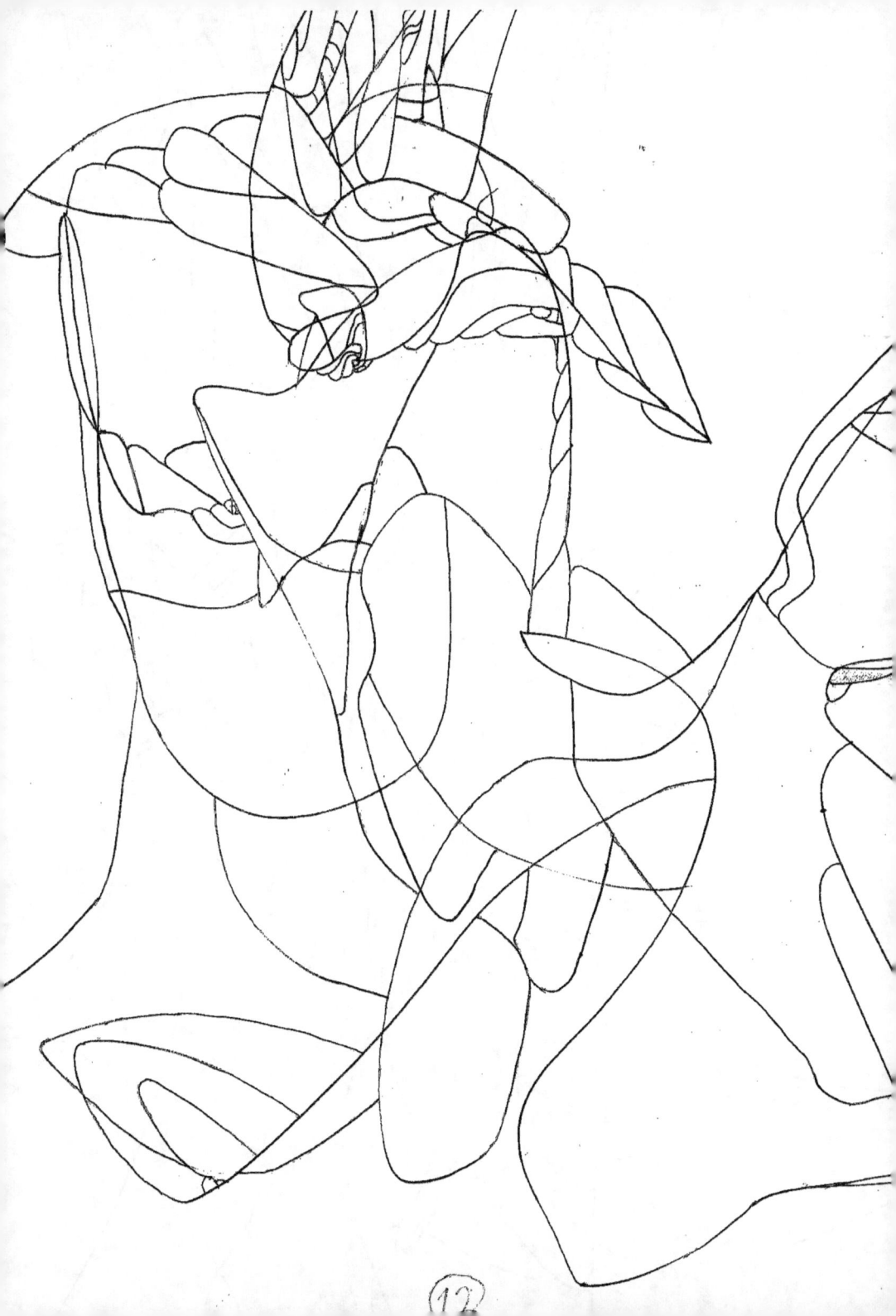

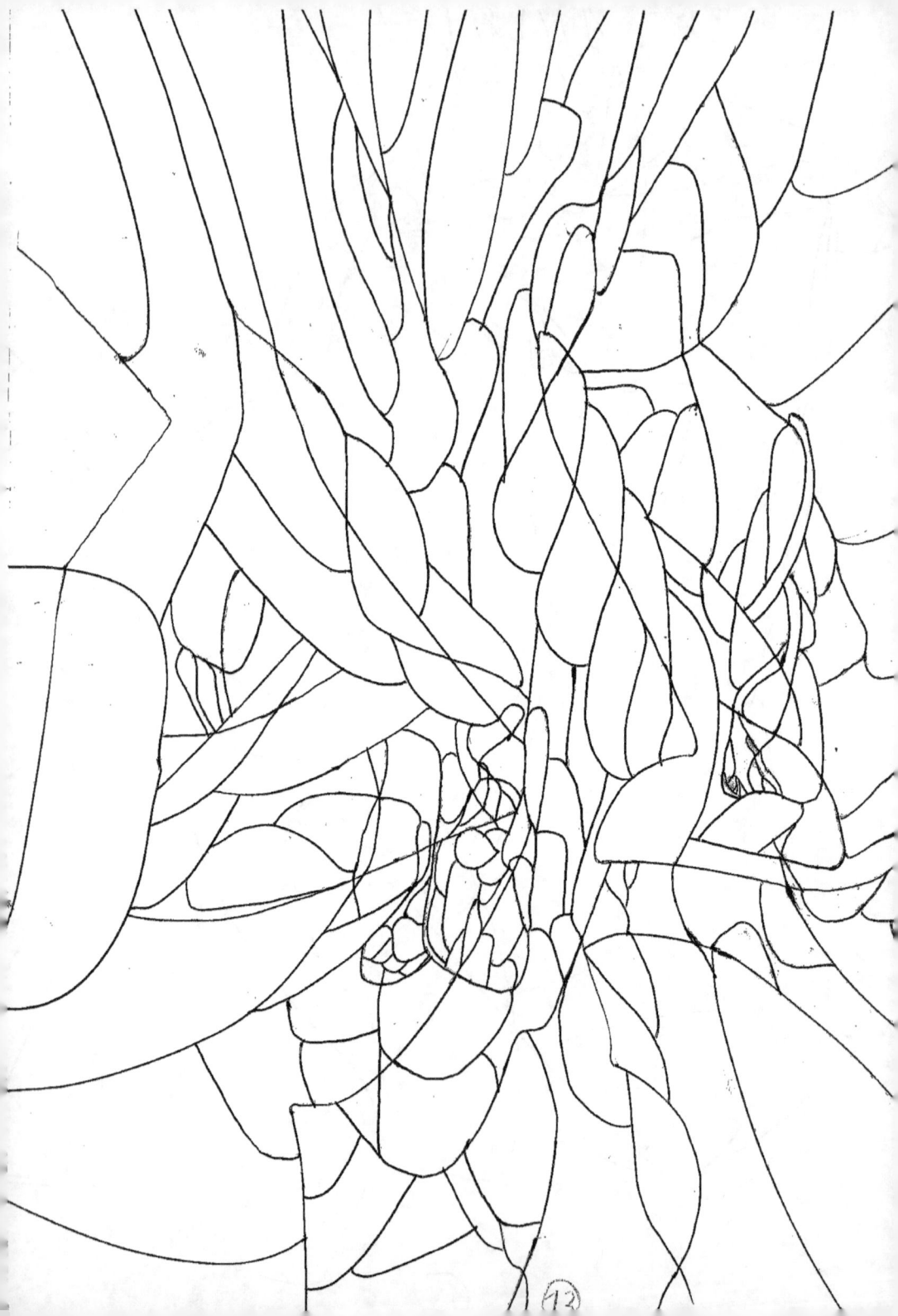

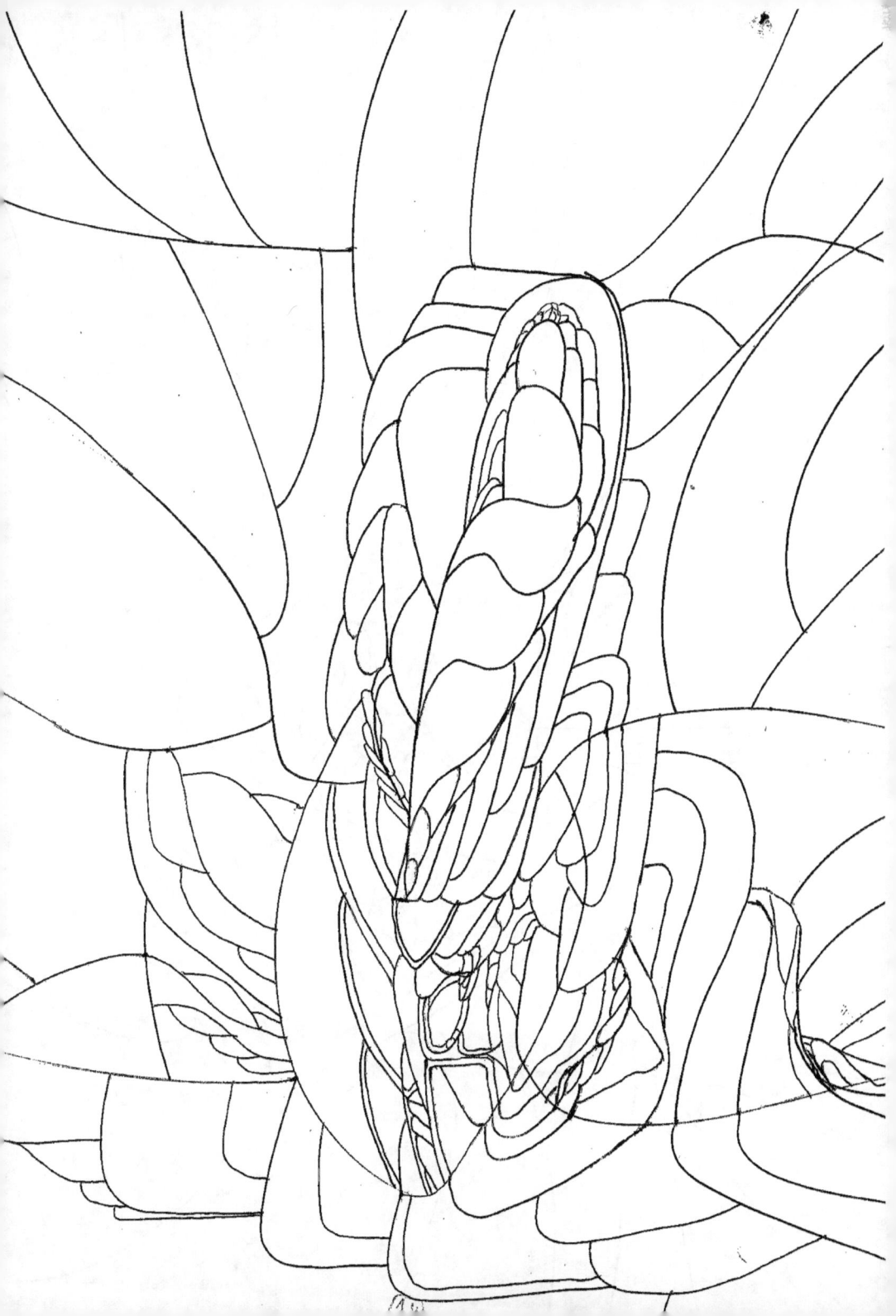

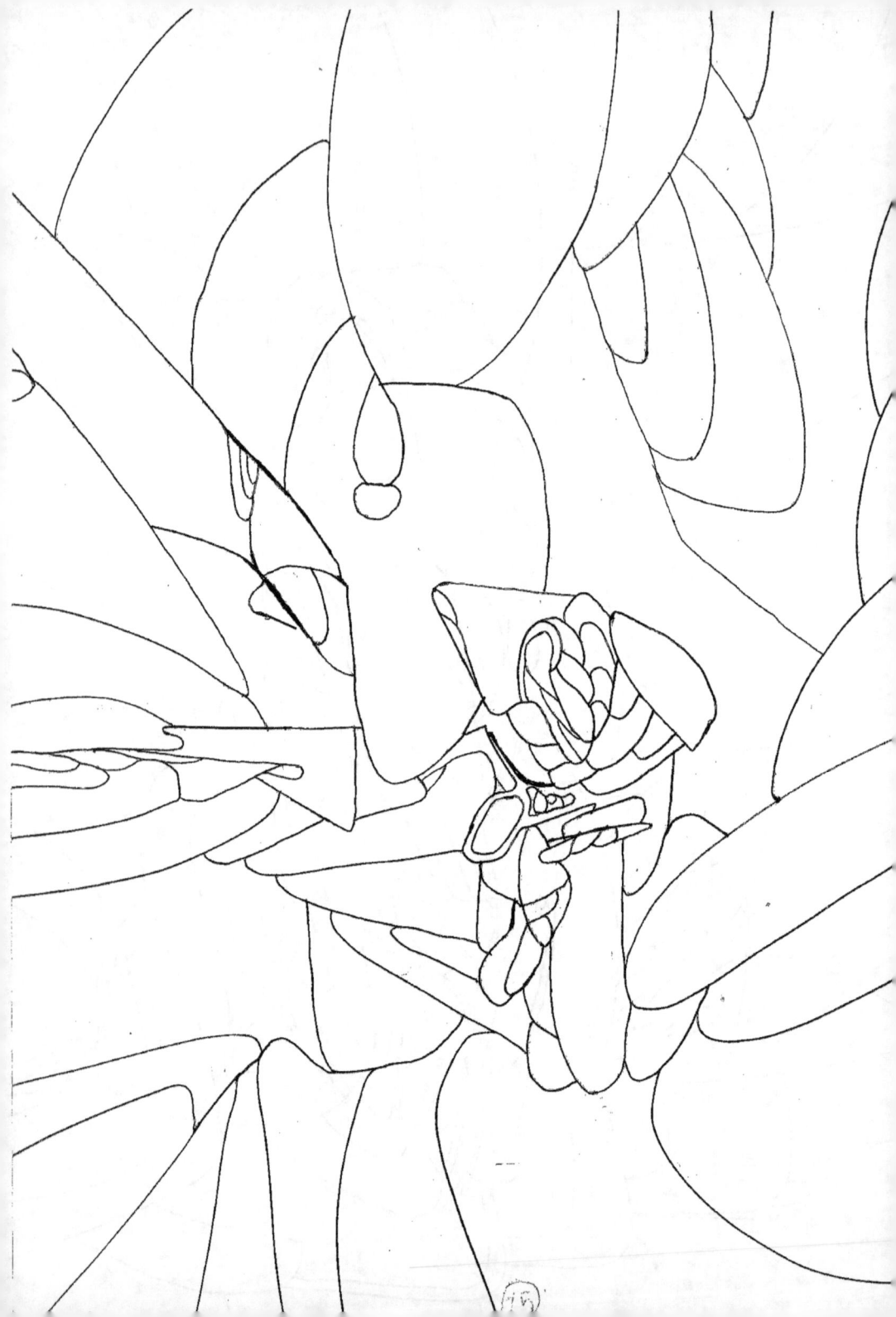

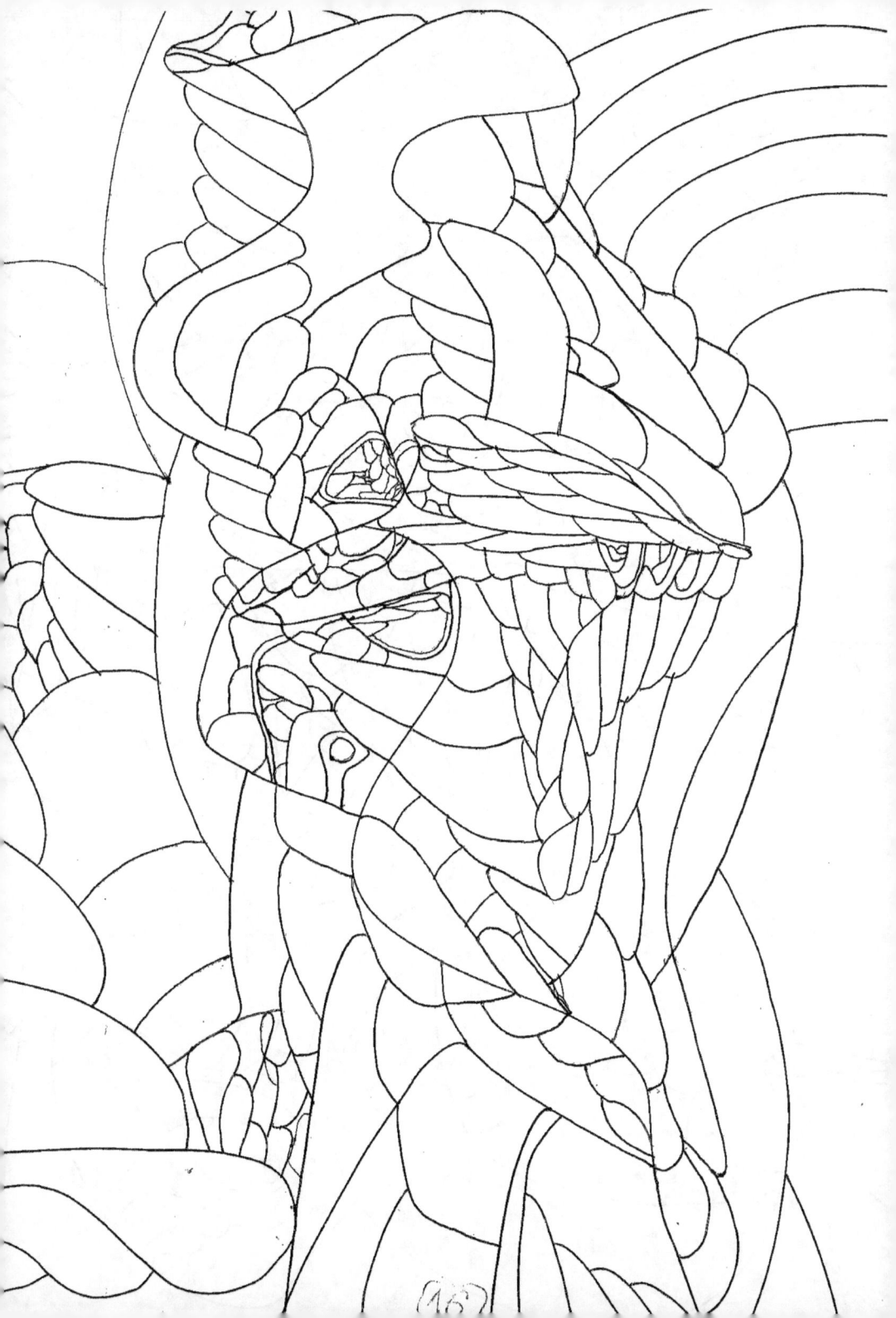

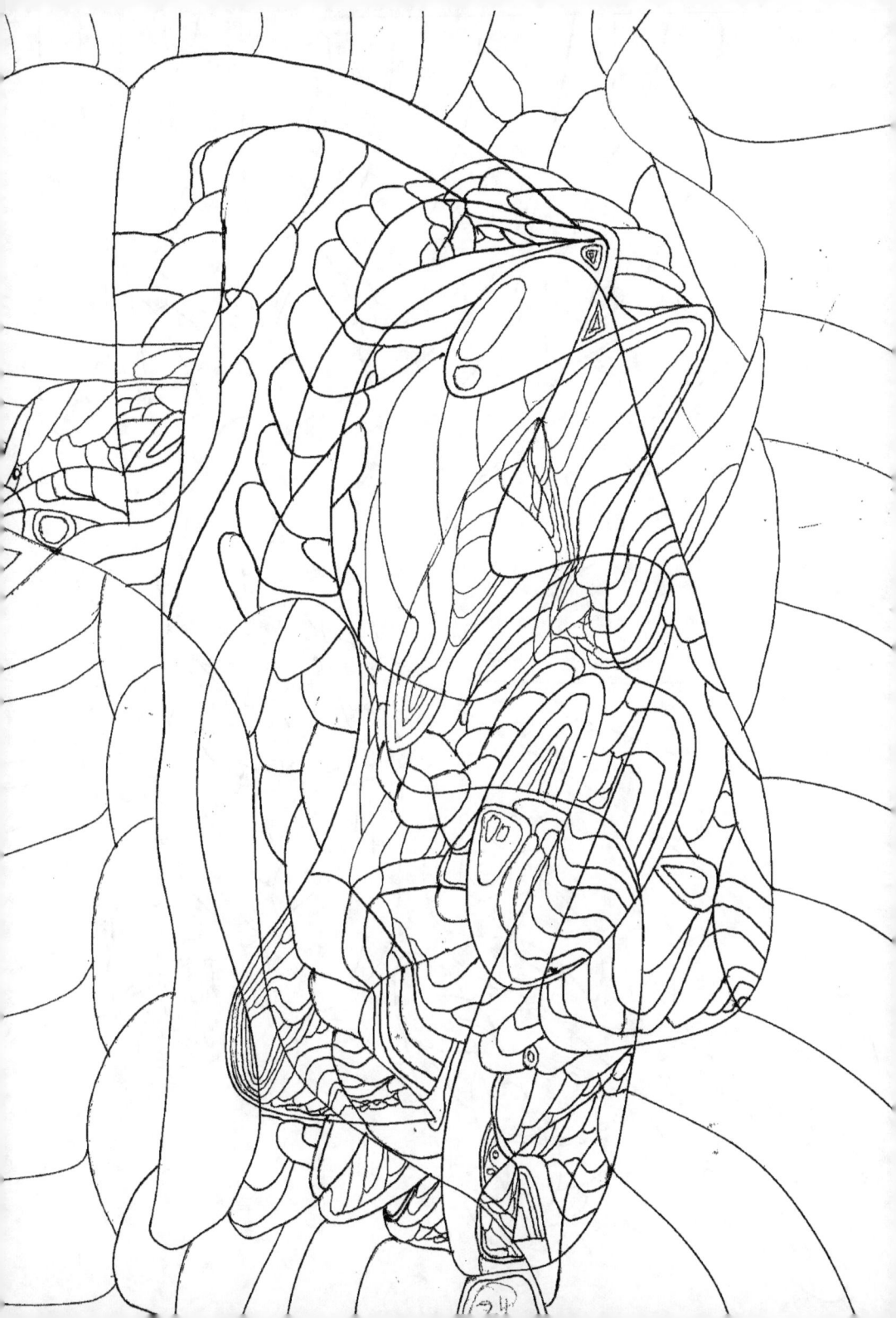

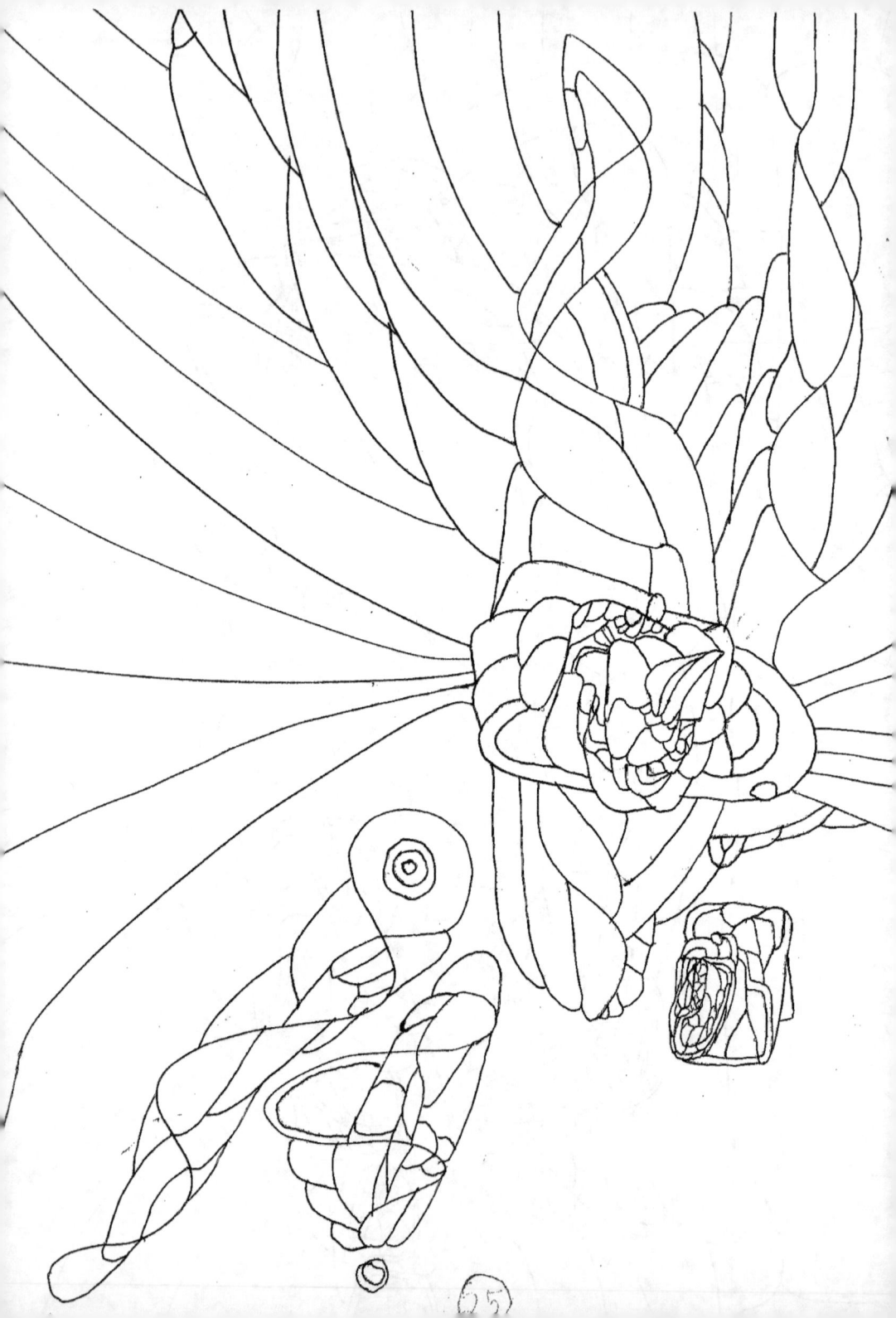

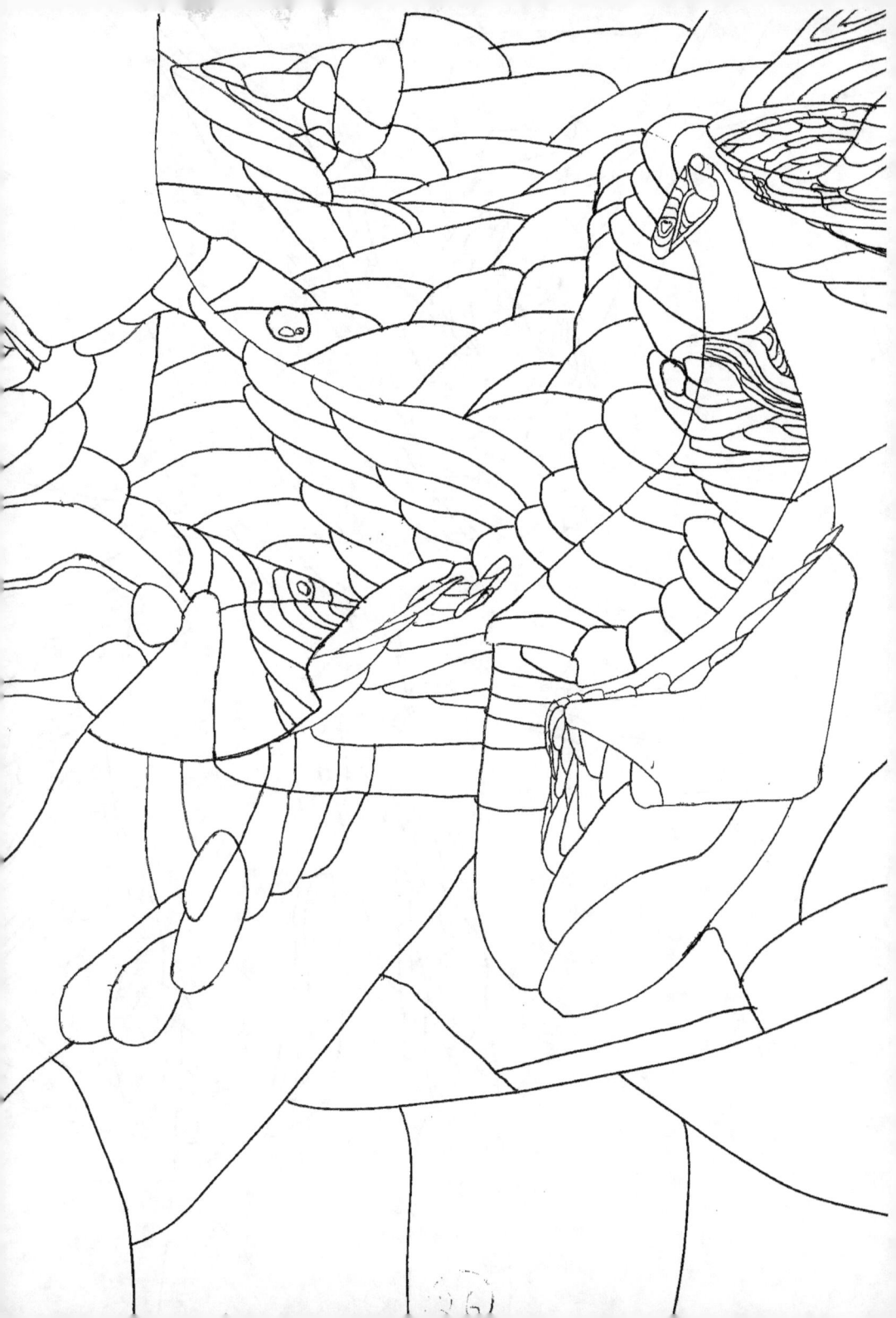

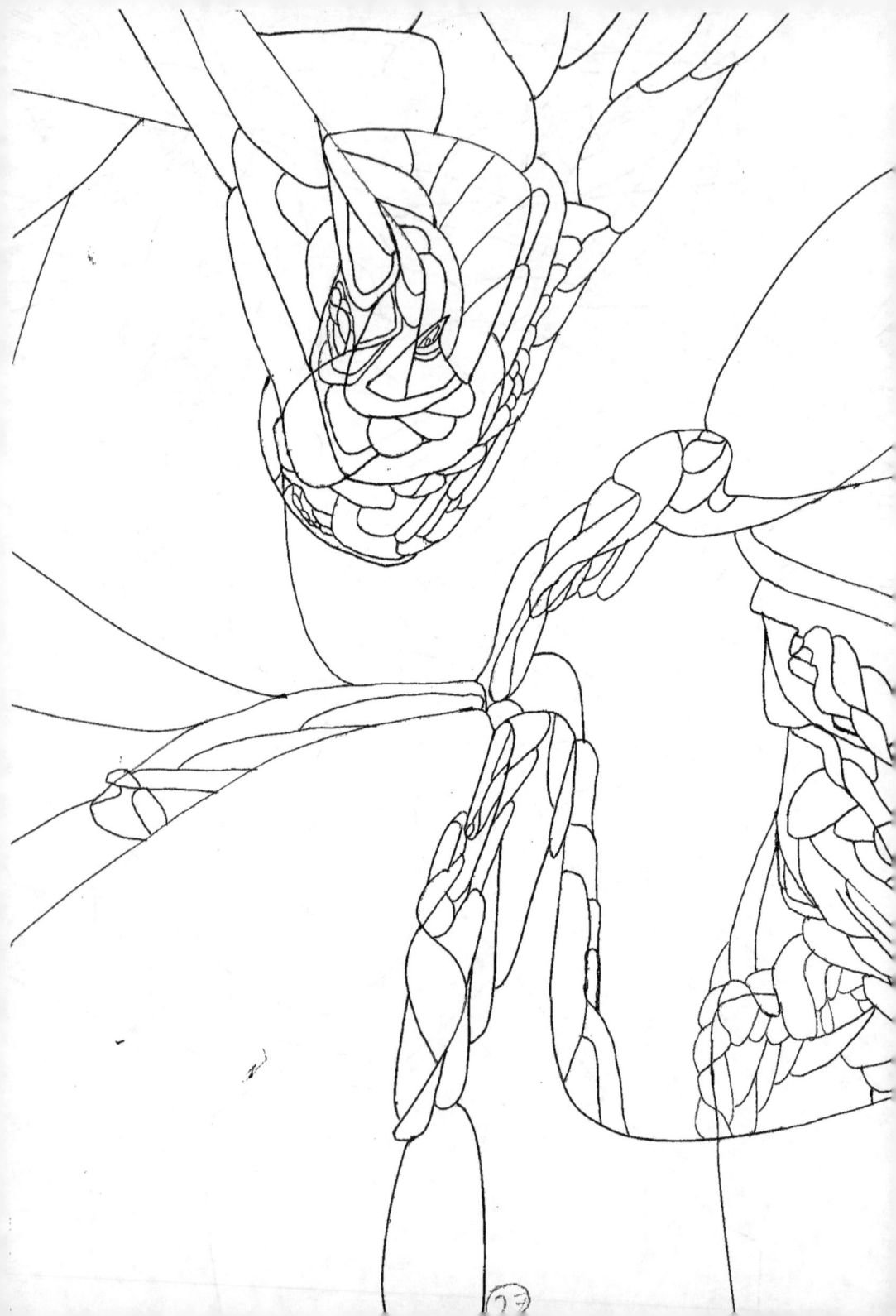

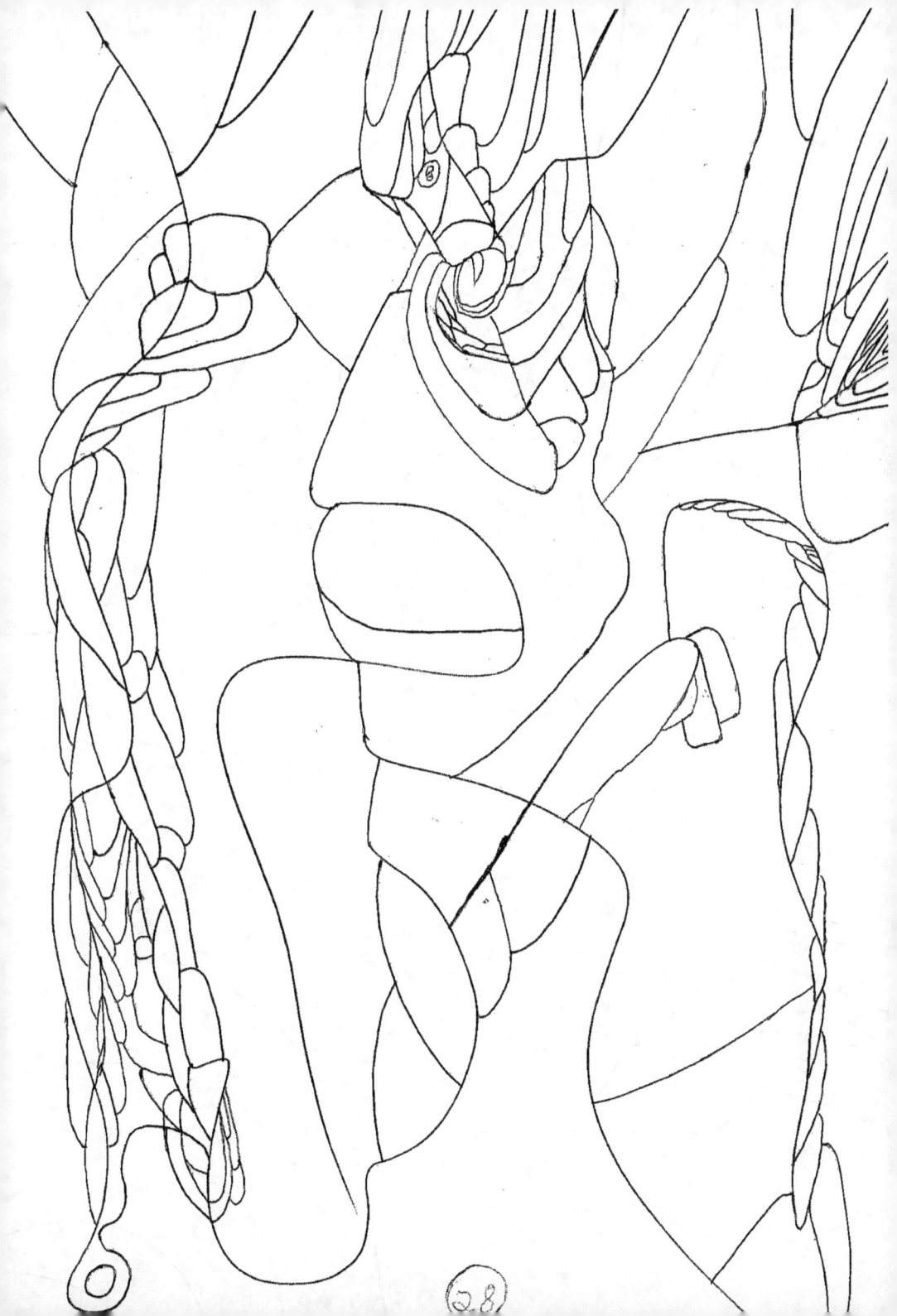

www.ingramcontent.com/pod-product-compliance
Lightning Source LLC
Chambersburg PA
CBHW072306170526
45158CB00003BA/1209